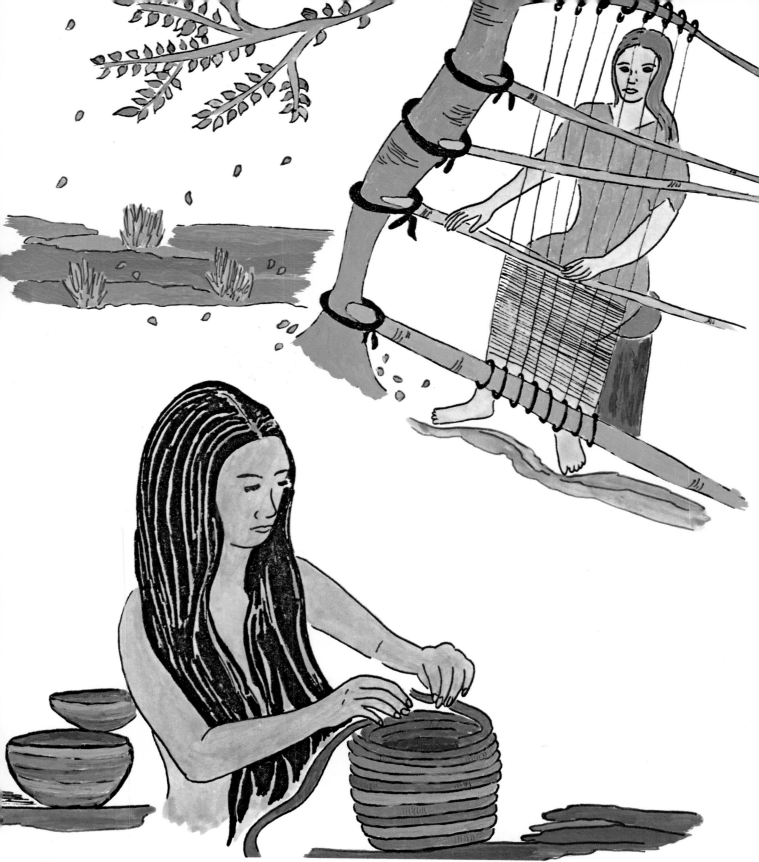

Women have always been creative artists. Thousands of years before history was written in books, women created beautiful baskets and clay pots. Many years later, women learned how to weave, dying threads into colors to make cloth. Women learned how to sew and decorated their clothing with beads.

1

Many many more years passed and people started to live in small villages. Most women were so busy that they had very little free time, and an artist needs some free time to create. Women spent much time caring for their children and home, going to market, raising vegetables and fruit, milking cows, making cheese and butter, baking bread, preparing meals, making candles, and weaving cloth to create clothing for their family.

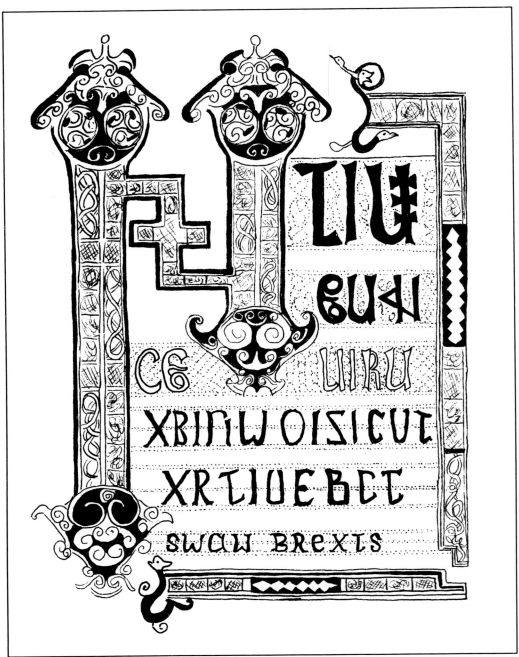

A copy of religious writing called an illuminated manuscript. Color would have been added to the original.

From the 10th to the 13th centuries in Europe, there were small groups of women who were more lucky than others. Women from wealthy families, royalty or those who became nuns were often given good educations and had more free time to be creative. They used their skills to weave tapestries, embroider hangings for churches and decorate pages of religious writings.

SOFONISBA ANGUISSOLA (Italy, 1532/35-1625)

Although it was very unusual for a woman to have a career outside her home in the 16th century, Sofonisba Anguissola became the first well-known woman artist and inspired many other women to become artists.

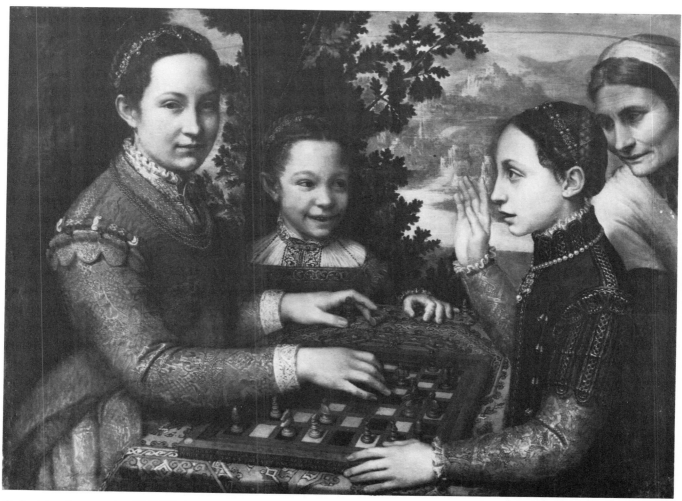

Sofonisba Anguissola, THREE SISTERS PLAYING CHESS. (1555). 27 3/16" × 35 7/8". Museum Narodowe W. Poznaniu, Poznan, Poland.

The 16th century Renaissance (which means re-birth) was a time of re-awakening in the arts. Education for women from wealthy families was encouraged. As Sofonisba Anguissola came from a wealthy Italian family, she and her five sisters were all taught to read Italian and Latin, write poetry, play musical instruments and paint. Sofonisba's good education helped her discover that she had artistic talent. Sofonisba painted many self-portraits and then created a whole new kind of painting with people not just sitting still for a portrait, but placed in scenes of daily life. Sofonisba's painting of her three sisters playing chess is probably one of the first examples of this type of painting. Her talents in painting portraits became known and she was invited to paint in the Court of King Philip of Spain. She worked there for twenty years and was very well paid for her great talent. After her first husband died, she re-married and continued to paint until the age of ninety-six.

LAVINIA FONTANA (Italy, 1552-1614)

Lavinia Fontana was the first woman artist to create paintings for large public places, such as churches. She also painted many portraits.

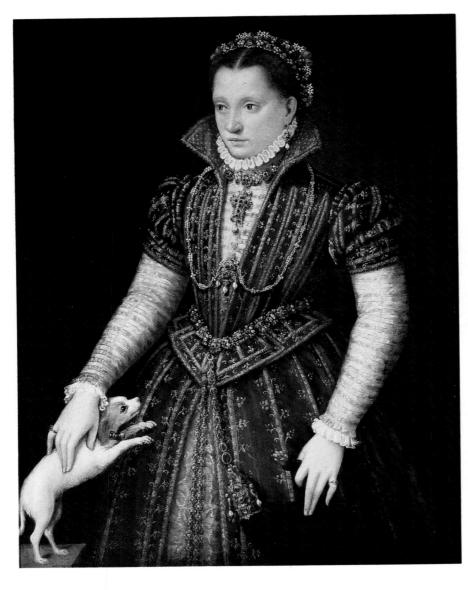

Lavinia Fontana, PORTRAIT OF A NOBLEWOMAN, (c. 1580). Oil on canvas, 45 1/4 × 35 1/4". The Holladay Collection. The National Museum of Women in the Arts.

In Bologna, Italy, Lavinia's artist father taught her about painting. Soon, fashionable men and women came to Lavinia for their portraits because she made them look beautiful in their fine clothing and jewelry. The Pope heard about Lavinia and asked her to move to Rome to paint religious works. At the age of twenty-five, she married a man who promised to help Lavinia keep her career as an artist. Her husband painted some of the backgrounds in her paintings and helped do housework in their home. They had eleven children, only three of whom lived to be adults. One hundred thirty-five works by Lavinia Fontana are known today, more paintings than for any other woman artist before the year 1700. Sadly, the paintings of many women artists of the past have been lost.

In the 16th and 17th centuries, there were no schools to teach art. A student with talent worked for an artist and this learning experience was called an apprenticeship. Only male students were allowed to be apprentices. Young girls from wealthy families were given art training, but other girls who showed artistic talent could only be taught about art if they were lucky to have an artist as a father.

ARTEMISIA GENTILESCHI (Italy, 1593-1652)

Artemisia Gentileschi is thought by many experts to be the greatest of Italian women artists, painting women's strength as well as beauty.

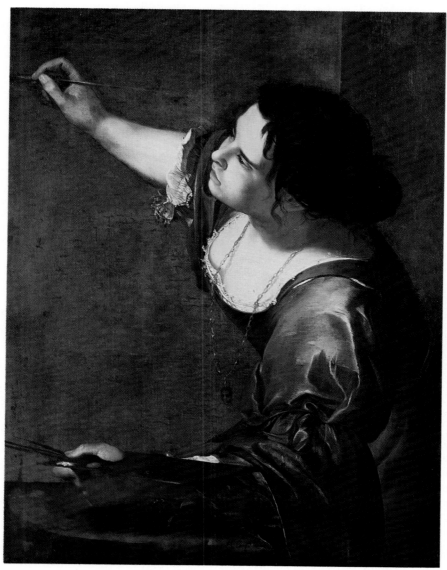

Artemisia Gentileschi, SELF PORTRAIT AS LA PITTURA. Oil on Canvas, 38½" × 29½". COPYRIGHT RESERVED TO HER MAJESTY QUEEN ELIZABETH II.

Artemisia's father was an artist who taught her what he knew about painting. Then her father hired another art teacher. Unfortunately, she was treated very badly by this man. Because of this experience, Artemisia often created paintings about powerful women of courage, using stories from the Bible, history, or ancient myths. Some of her paintings were very large, over six feet high, and had dramatic shadings of color. Artemisia had an unhappy marriage and left her husband, but she never left her work as an artist, painting throughout her life. Artemisia was famous in her time, signing her paintings with her father's name, Gentileschi, rather than by her married name.

In 17th century Holland, women had more control of their lives than in other countries and were able to study art with expert painters who were not related to them.

JUDITH LEYSTER (Holland, 1609-1660)

Judith Leyster was unusual because she was an expert in not one, but three types of paintings: still-lifes, scenes of daily life, and portraits. Judith was an example of a woman artist whose name was almost lost because her works were thought to have been created by a man.

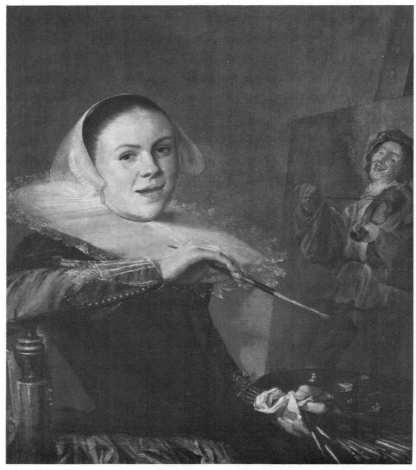

Judith Leyster, SELF-PORTRAIT, (c. 1635), 29 3/8" × 25 5/8". National Gallery of Art, Washington, D.C. Gift of Mr. and Mrs. Robert Woods Bliss.

Judith Leyster was exceptional for many reasons. She became an artist, even though her father was not an artist. It was unusual for a woman to be accepted into the Artists Guild and to have male students, yet Judith was invited into the guild and had three male students. Judith painted three different types of works: scenes of life around her, portraits, and still-lifes. Judith Leyster signed her paintings with her initials J L and then added a star. This stood for her last name which meant "Lodestar." For many years, some of her paintings were thought to have been created by a male artist of her day, Frans Hals, until the paintings were cleaned well, and the J L * was discovered. Judith married an artist and had three children. After marriage, she had very little time to paint.

MARIA SIBYLLA MERIAN (Germany, 1647-1717)

Maria Sibylla Merian combined her talent in art with her interest in science. She created paintings and wrote books about plants and insects that were so good, scientists used them for study.

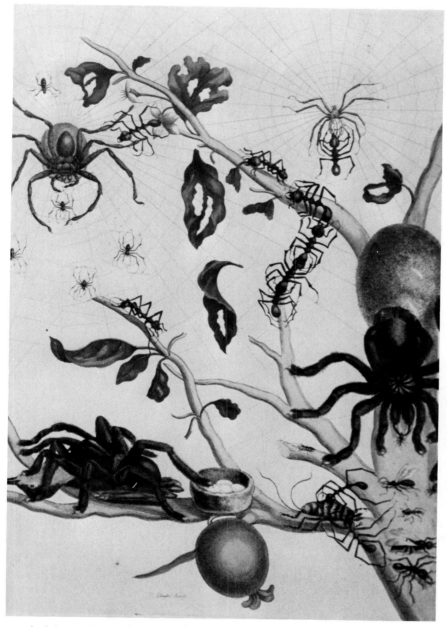

Maria Sibylla Merian, Illustration from DISSERTATION IN INSECT GENERATIONS AND METAMORPHOSIS IN SURINAM. Bound volume of 72 hand-colored engravings, 2nd edition. (1719). The Holladay Collection. The National Museum of Women in the Arts.

As a child in Germany, Maria loved to study and collect insects. Her step-father, a flower and insect painter, encouraged Maria and taught her about painting. Maria then created water color pictures of birds and insects, such as spiders, caterpillars, and ants. As a young woman, she wrote and illustrated several books about insects, which were so accurate they were used by scientists. Divorced from her husband, adventurous Maria, at the age of fifty-two, traveled to South America with one of her two daughters. They lived in the jungle of Surinam where Maria could paint the birds, insects and flowers. Her nature studies in Surinam also became a book, and Maria was then known as a scientist as well as an artist.

"Still-life painting" (usually flowers, fruit, and beautiful objects) became popular in the 17th and 18th centuries. Since women artists were not allowed to study the nude male figure, they found other subjects instead. Many women artists became excellent still-life painters.

RACHEL RUYSCH (Holland, 1664-1750)

Rachel Ruysch is thought to be one of the greatest still-life painters of Holland.

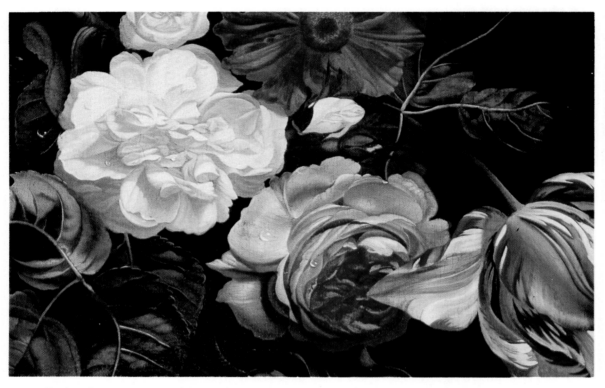

Rachel Ruysch, detail of FLOWERS IN A VASE, oil on canvas, 18 3/4" × 15 3/4". The Holladay Collection. The National Museum of Women in the Arts.

Rachel's interest in flowers and small insects came from watching her father, a professor of anatomy and botany, study animals' bodies and plants. At the age of fifteen she studied flower painting with an artist, and soon her own paintings of flowers became so popular that she was paid large amounts of money for them. A ruler in Germany liked her work so much that he invited both Rachel and her husband, also a painter, to be his court painters for eight years. Rachel had ten children and did what few women artists who were married and had children were able to do; she continued to paint. She created beautiful flower and fruit paintings until the age of eighty-three.

Black, red, and white chalks had been known by artists for a long time and were usually used for sketching. At the end of the 15th century in France, a new soft chalk called pastel was invented and made in many colors. Only a very few artists had used pastels until Rosalba Carriera.

ROSALBA CARRIERA (Italy, 1675-1757)

Rosalba Carriera was the first artist to explore the special uses of chalk and made pastel portraits popular.

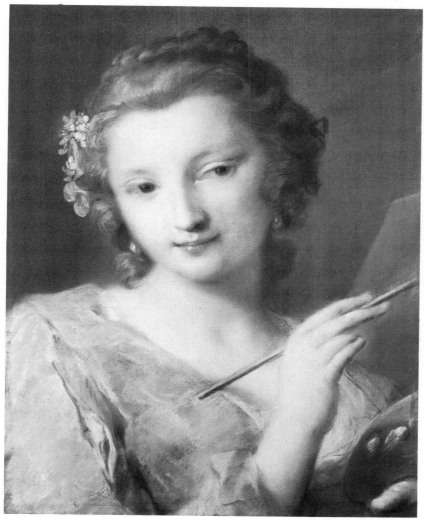

Rosalba Carriera, ALLEGORY OF PAINTING, (c. 1720). Pastel on paper, 17¾ × 13¾". National Gallery of Art, Washington, D.C. Samuel H. Kress Collection.

Rosalba was given a present of beautiful colored chalks by a family friend. She had been creating very tiny oil paintings on small ivory boxes, but loved working with the chalks even more. She could build up layers of colors and form lacy looks just by rubbing the chalk with her thumb. Rosalba became so good at creating pastel (chalk) portraits, that hundreds of people including many royal visitors came to her. A French art collector invited Rosalba and her family to leave their home in Venice and come to Paris. Rosalba was the first artist to introduce pastel portraits to France. She was invited to be one of the few women members of the French Academy of Painting and was also a member of the Academy in Rome, Italy. The last years of her life were very sad ones because she had become blind.

MARIE LOUISE ELISABETH VIGEE-LEBRUN
(France, 1755-1842)

Elisabeth Vigee-Lebrun painted over 900 portraits during her long lifetime and was one of the best portrait painters of the late 18th and early 19th centuries.

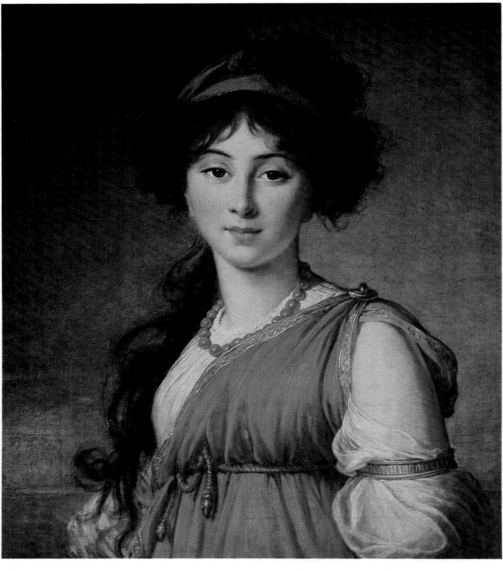

Marie Louise Elisabeth Vigee-Lebrun, VARVARA IVANOWNA NARISHKINE NÉE LADOMIRSKY, (1800). Oil on canvas, 25 × 21¾". Columbus Museum of Art, Ohio: Museum Purchase, Derby Fund.

Elisabeth painted portraits of almost all the royalty of Europe. They had heard about Elisabeth because of the many portraits she had painted of Marie Antoinette, the Queen of France. Elisabeth's fame made her one of only three women to be invited into the French Royal Academy of Painting. When Queen Marie Antoinette was arrested because of the French Revolution, Elisabeth, fearful for her own life, quickly left her home in Paris. She then traveled throughout Europe for many years, painting portraits for royal families in whatever city she visited. Although she was very well-known, she did not become wealthy because her husband was a gambler and lost much of her hard earned money. She and her husband separated, and Elisabeth took their daughter everywhere with her. Elisabeth was inspired to become an artist because of her father who was also a portrait painter.

In the 18th century, the best artists were invited to join academies of art where they studied and could show their work. Very few women were permitted to join. No women were allowed to draw from nude male models. Women had to understand the male body in order to paint full length portraits of men or large history paintings. Some women managed to produce excellent paintings of men, but then were sometimes falsely accused of having a man create their paintings.

ANGELICA KAUFFMAN (Switzerland, 1741-1807)

Angelica Kauffman had the courage to paint "history paintings," huge paintings about important events, even though it was believed women were not good enough artists to paint these subjects. She was also a well-known portrait painter for all of Europe.

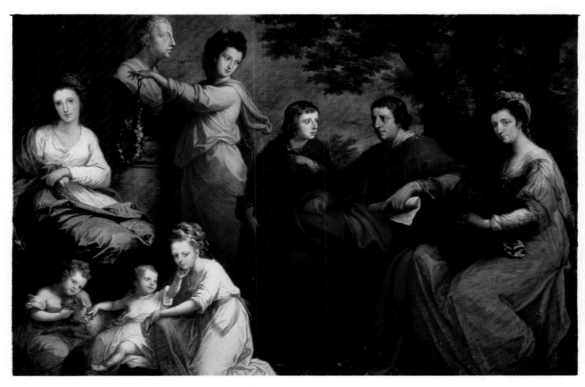

Angelica Kauffman. THE FAMILY OF THE EARL OF GOWER. (1772). Oil on canvas. 59¼ × 82". The Holladay Collection. The National Museum of Women in the Arts.

Angelica was born in Switzerland, but spent her youth traveling in Austria and Italy with her father who had jobs as an artist. Angelica showed a great deal of talent in both music and art, but at the age of nineteen made the difficult decision to concentrate on art. It was believed that only men could paint history scenes, but Angelica Kauffman refused to accept this idea. She created many history paintings and helped introduce "Neoclassicism" (art in the style of ancient Greece and Rome). Angelica also painted such good portraits that royalty from all over Europe came to her when she visited their city. She became a wealthy woman, visited by many famous writers and artists. One of her visitors became her first husband, but he was a dishonest man who already had another wife. Her second husband was an artist who helped manage her money, which gave Angelica more free time to paint. Angelica Kauffman was so well respected that she was asked to be one of the founders of the British Royal Academy, a society for artists which invited only two women members.

SARAH MIRIAM PEALE (U.S., 1800-1885)

Sarah Peale was the first professional woman painter in America because she was able to support herself with the money she earned painting.

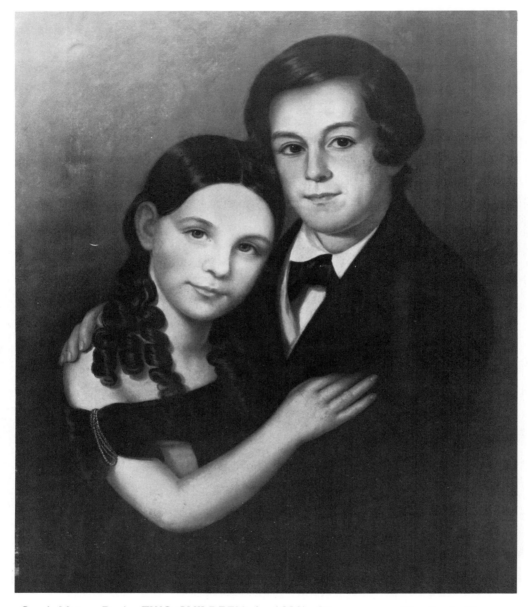

Sarah Miriam Peale, TWO CHILDREN, (c. 1830), Oil on canvas. The Peale Museum, Baltimore, Maryland.

Sarah's uncle, the famous artist Charles Willson Peale, believed in women's abilities in art and named his children after well-known artists of the past. His daughters' names were Sofonisba Anguissola Peale, Angelica Kauffmann Peale, Rosalba Carriera Peale, and Sibylla Merian Peale. Uncle Charles and Sarah's father, also a painter, became her teachers. Sarah painted portraits of people in government when she lived in Washington D.C. She painted many portraits and still-lifes in two other cities where she lived, Baltimore and St. Louis. Sarah made the decision never to marry in order to devote her life to her art. Many of her sisters, brothers and cousins also became artists. They were called "The Painting Peales."

ROSA BONHEUR (France, 1822-1899)

Rosa Bonheur's paintings of animals made her so well-known that a "Rosa Bonheur Doll" was created for young girls. She was one of the most popular women artists of the 19th century, inspiring many women to become artists.

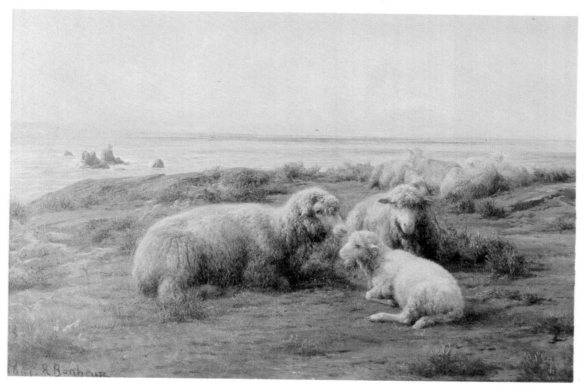

Rosa Bonheur, SHEEP BY THE SEA, (1869). Oil on cradled panel, 12 3/4 × 18". The Holladay Collection. The National Museum of Women in the Arts.

Rosa loved animals so much that her pet sheep lived on the balcony of her sixth floor apartment in France when she was a young girl. Her brothers carried the sheep downstairs for daily exercise. She sketched the sheep as well as other animals she saw in the countryside, at fairs, and at horse auctions. She created realistic animal paintings and sculptures which were so well liked that the queens and kings of many countries of Europe gave Rosa medals for her art work. With the money she earned painting, she bought a large home and studio, which included a farm for the animals she wanted to paint. Some of Rosa's actions were different from those of other women at the time she lived. She decided to be independent and did not want to marry, living instead with her close friend Nathalie Micas for forty years. She dressed for comfort, wearing slacks and kept her hair short, even though almost all other women of her day wore dresses and had long hair. Because she was a woman, Rosa had to get a special permit from the police to wear slacks. Rosa's father inspired her with his ideas that women can do and be anything. He was an artist and the teacher of his four children who all became artists.

EDMONIA LEWIS (U.S., 1843-1909?)

Edmonia Lewis was the first black American to be known world-wide as a sculptor.

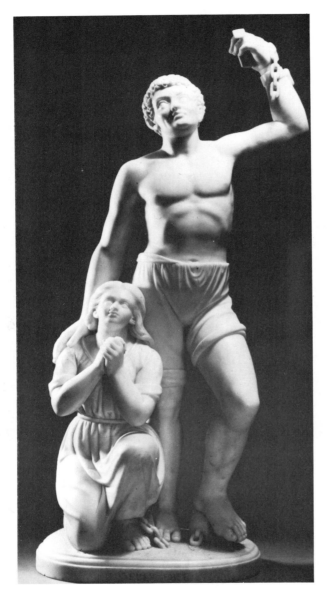

Edmonia Lewis, FOREVER FREE, (1867). Carrara Marble, Height: 41 1/4". Howard University, Gallery of Art, Washington, D.C.

Edmonia's father was an American Negro and her mother a Chippewa Indian. At four years old, Edmonia became an orphan and was raised by members of her mother's Chippewa tribe in New York. Her early years with the tribe were spent wandering, fishing, swimming, and making moccasins. As a teenager she was adopted by an abolitionist (against slavery) family. Her adopted family encouraged her to enter the first college in the United States to accept women and people of different races, Oberlin College. On a visit to Boston, Edmonia was impressed with the sculptures she saw. A friend introduced her to a sculptor who became her teacher. With money from the sale of her first sculpture, she went to Italy, working with other women sculptors. Many of the marble sculptures Edmonia created show her feelings against racial prejudice and slavery.

HARRIET HOSMER (U.S., 1830-1908)

Harriet Hosmer was a very famous woman sculptor. Her fine work encouraged other women to become sculptors.

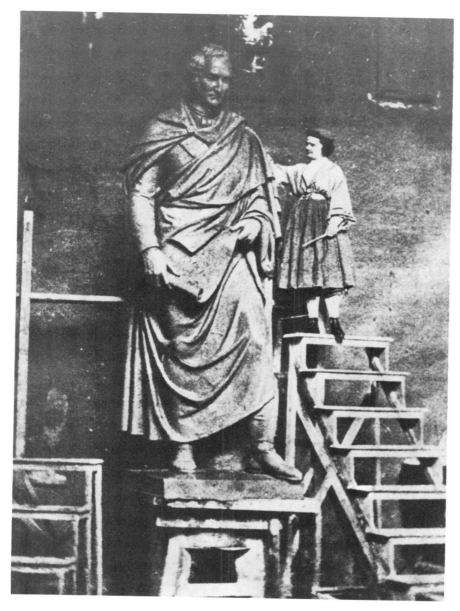

Photograph of Harriet Hosmer at work on her statue of Senator Thomas Hart Benton.

Harriet's mother, sister and brothers died when Harriet was very young. Her father, a doctor, did not want to lose his only remaining child. He encouraged Harriet to be healthy by being outdoors where she hunted, fished and climbed mountains, unusual for women of that time. Mt. Hosmer in Missouri is named for Harriet. Harriet wanted to understand the human body and took anatomy classes in medical school, the only place where women were allowed to study the human form. Here she started to sculpt. She went to Rome, Italy, to learn more about sculpting. Her park fountains and statues were sold to people in the U.S. and Europe. Harriet dressed the sculptures in clothing of ancient Roman people rather than in the fashion of her day. Harriet decided not to marry because she felt she could not be both a good wife and a good artist. She chose art for her life's work.

MARY CASSATT (U.S.,/France, 1844-1926)

Mary Cassatt, an American woman artist who lived in France, is best known for paintings of mothers and children.

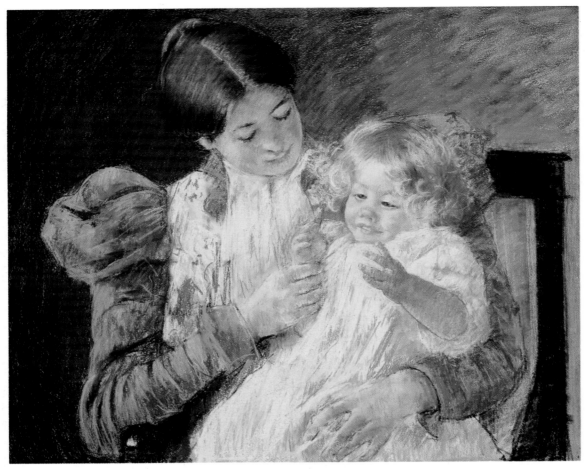

Mary Cassatt, PATTY CAKE, (1897). Pastel on paper, 23″ × 28 1/2″. The Denver Art Museum, Denver, Colorado.

When Mary told her family that she wanted to become an artist, her father became very upset. Mary firmly convinced her family of her right to have a career, and was then able to study art in her home state of Pennsylvania as well as in Paris, France, where she lived for the rest of her life. Her family visited her often, finally moving to Paris to be with her. She took care of them, and never married. Her family became the subjects of her paintings, looking very natural and relaxed. Mary especially enjoyed painting pictures of mothers and children. She joined a group of artists called "Impressionists" who tried to capture in paint the sparkle and changes of light on objects. Her friend, the artist Edgar Degas, showed her many ways to use pastels (colored chalks), and Mary Cassatt became one of the greatest pastellists of the 19th century. Edgar Degas also taught Mary ways to make prints, and she is famous for the beautiful prints she then created. Mary gave advice to some of her wealthy American friends about which "Impressionist" and other paintings to buy. Many of these paintings were later given to United States museums. Thanks to Mary Cassatt's excellent taste, U.S. museums own some of the finest paintings in the world.

GEORGIA O'KEEFFE (U.S., 1887-1986)

Georgia O'Keeffe created works that showed her wonder of the world, often painting small objects so large they had to be noticed. Many people think she is the most successful woman artist of the 20th century.

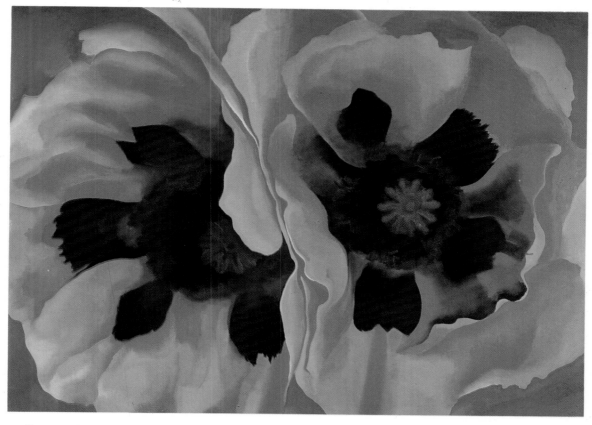

Georgia O'Keeffe, ORIENTAL POPPIES, (1928). Oil on canvas. Height: 30″, Width: 40 1/8″. Collection University Art Museum, University of Minnesota, Minneapolis / Purchase, 37.1.

Georgia had wanted to be an artist since she was ten years old. She took art lessons and as an adult became an art teacher while continuing to paint. At the age of thirty she suddenly realized that her paintings were copies of the art styles of others. She bravely destroyed all she had painted. Georgia made herself a promise: "I will only paint what pleases <u>me</u>!" Her greatest paintings then developed. Alfred Stieglitz, a famous photographer, was so impressed with Georgia's paintings that he immediately exhibited them in his art gallery. Alfred and Georgia were married, but she had the courage to leave her husband each summer and go alone to paint in the peace and beauty of the New Mexico desert. When Alfred died, Georgia moved to a ranch in the desert for the rest of her ninety-eight years. Using bright color, she painted objects like flowers, shells, and bones, sometimes so large that they filled the entire canvas. Georgia O'Keeffe expressed the great beauty of the world in a new way.

AUGUSTA SAVAGE (U.S. 1892-1962)

Augusta Savage was an important sculptor who helped black artists to be known in the United States.

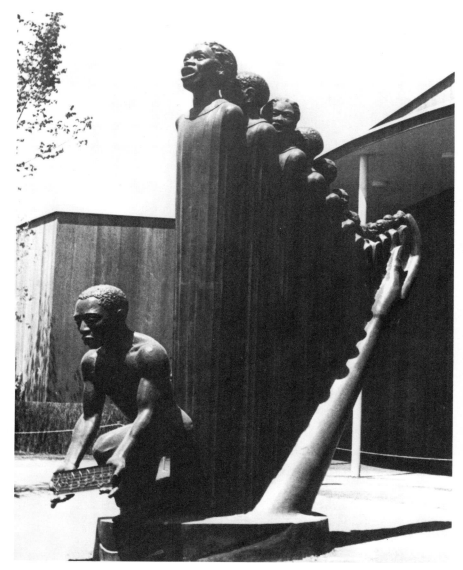

Augusta Savage, LIFT EVERY VOICE AND SING, (1939) (destroyed), cast sculpture. Photograph by Carl Van Vechten. Collection of American Literature, Beinecke Rare Book and Manuscript Library, Yale University. Courtesy of Joseph Solomon, executor of the Estate of Carl Van Vechten.

Augusta was the seventh of fourteen children born to a poor family in Florida. After studying sculpture in New York on a scholarship, she wanted to study in France. Because of prejudice against the color of her skin, Augusta was not allowed to enter the school. She worked in laundries and factories to support herself. At the age of thirty, she was given a Fellowship (money) to study in France. Returning to New York, Augusta opened her own art school where she taught young people who later became important black artists. She helped many black artists get jobs when she was the director of the Harlem Art Center. Augusta was asked to create a sculpture for the 1939 New York World's Fair and chose as her subject black American music. She named the sculpture "Lift Every Voice and Sing." Very sadly, a bulldozer destroyed this important plaster sculpture when the World's Fair was over, because there was no money to cast it into bronze.

LOUISE NEVELSON (Russia,/U.S., 1899-1988)

Louise Nevelson was one of the first sculptors to combine "found objects" (broken and used) to create beautiful new sculptures in wood.

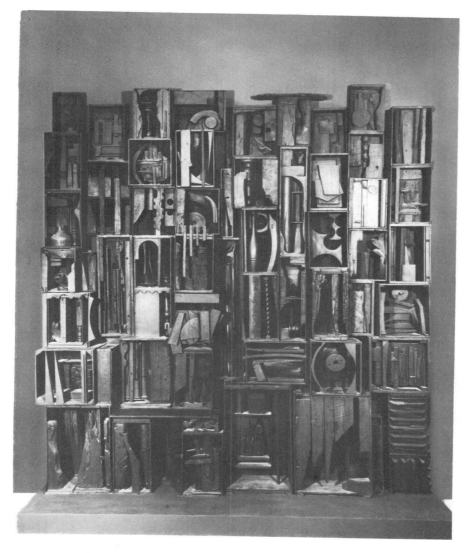

Louise Nevelson, SKY CATHEDRAL, (1958). Assemblage: wood construction painted black, 11' 3 1/2" × 10' 1/4" × 18". Collection of the Museum of Modern Art, N.Y. Gift of Mr. and Mrs. Ben Mildwoff.

Louise moved from Russia to the U.S. when very young. As a child, she created her first sculptures out of pieces of scrap wood which she found in her father's lumber yard. Her parents believed in equality for women and encouraged Louise's desire to become a sculptor by sending her to art teachers in the United States and Europe. Louise had a short, unhappy marriage which ended in divorce, but she raised her young son and he became a sculptor like his mother. Louise made her unusual sculptures by stacking together empty wood crates and boxes, creating a wall. She then found and added broken pieces of wood from parts of a chair, tops of a lamp, a toy or any object that had an interesting shape. Louise painted all the pieces one color, usually black, but sometimes white or gold, and then glued them into the painted crates and boxes. She arranged the wood shapes in beautiful patterns. Louise Nevelson created a totally new kind of sculpture in wood.

Women have often expressed their artistic talent with a needle. Royal and wealthy women in the 12th century created beautiful embroidery with silver threads and small pearls. Women have woven, sewn and decorated their family's clothing and have created quilts for warmth that were works of art. The quilt artist planned her quilt, sewing hundreds of small pieces together into a balanced design and color scheme. When the quilt designer completed her art work, she sometimes signed her name and date in the corner of the quilt. The artist then invited a group of women to help sew the bottom layers of the quilt to the top, using thousands of tiny stitches. This was called a "Quilting Bee" and was a time to share ideas, skills, and materials. Quilts celebrated life's events, with patterns such as "Log Cabin," "Barn Raising," and "Bridal Quilt."

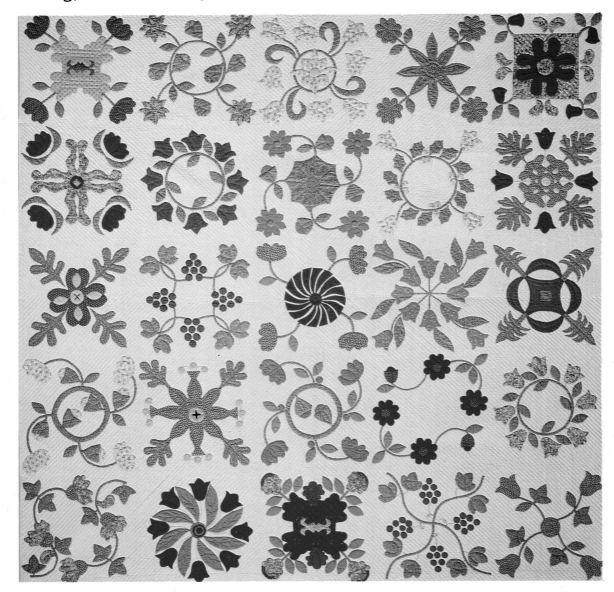

Charlotte Jane Whitehill, BRIDE'S QUILT. Cotton, 20th Century. Length: 82", Width: 84". The Denver Art Museum, Denver, Colorado.

CHARLOTTE JANE WHITEHILL (U.S., 1866-1964)

Charlotte's early years were spent in Kansas where she was an insurance company district manager. At age sixty-three, widowed Charlotte became interested in the pioneer art form of quilt making which her mother had taught her when she was a young girl. Charlotte copied and borrowed patterns that had been created in the past, producing over thirty-five museum quality quilts. Denver, Colorado became Charlotte Jane Whitehill's home toward the end of her life.

KÄTHE KOLLWITZ (Germany, 1867-1945)

Käthe Kollwitz's sculptures, drawings, and prints show her deep hatred of war and human suffering.

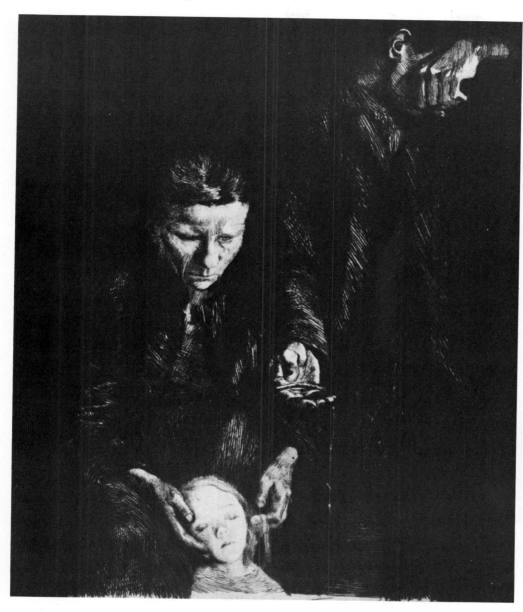

Käthe Kollwitz, THE DOWNTRODDEN, (1900). Etching, 12 1/8" × 9 ¾". The Holladay Collection, The National Museum of Women in the Arts.

Käthe grew up in Germany, where her father encouraged her to become an artist, sending her to art school. He did not think a woman could combine a family and a career. She proved her father wrong as she became a successful artist as well as wife and mother of two sons. Käthe was the first woman professor at the Prussian Academy of Arts. She helped German and Austrian women artists become known when she founded a society for women artists. Käthe was very fearful for her son's life when he joined the German army in World War I. Her worst fears came true when her son died in battle. Years later, her grandson also died in war. Her fear and dread of war lead her to become very active in speaking about political issues. Käthe Kollwitz expressed her great sadness in sculptures, drawings, and prints, all created in black and white, without the joy of color.

SOPHIE TAEUBER-ARP (Switzerland, 1889-1943)

Sophie Taeuber-Arp was one of the first artists to paint the beauty of simple shapes, making them vibrate with bright color.

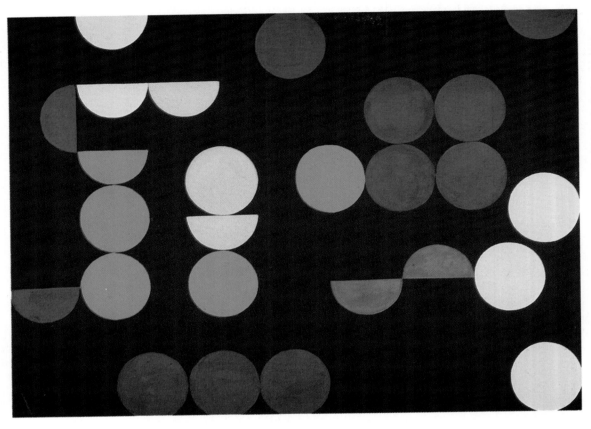

Sophie Taeuber-Arp, COMPOSITION OF CIRCLES AND SEMICIRCLES, (1935). Gouache on paper, 10 × 13 1/2". The Holladay Collection. The National Museum of Women in the Arts.

Sophie studied art in Switzerland where she was born. She became a professor of textile design, teaching for thirteen years. Sophie married the artist Jean Arp, and they influenced each other's art work. Sophie and Jean created their own works and sometimes designed pieces together. Sophie turned some of her husband's paintings into woven tapestries and taught him how to embroider so he could create his own fabric art. Sophie was talented in many ways: dancer, publisher of an art magazine, designer of her home in France, and painter. She liked to create order in her paintings. Sophie Taeuber-Arp used pure and simple geometric shapes, such as circles and rectangles, and painted them with glowing color. She was aware of the tension between the shapes, making them look as if they were dancing with joy.

ELAINE FRIED de KOONING (U.S., 1920 - 1989)

Elaine Fried de Kooning is able to paint both portraits and abstractions and sometimes combines both art forms.

Elaine Fried de Kooning, BACCHUS #3, (1978). Acrylic on canvas, 78 × 50″. The Holladay Collection. The National Museum of Women in the Arts.

Elaine grew up in Brooklyn, New York, where she often visited art museums. At the age of six, Elaine's drawing talent was noticed by her mother who encouraged her. As a teenager, she took art lessons from Willem de Kooning, who became her husband. He influenced her by his abstract art (colors and shapes that do not form objects). Elaine had much talent in drawing, which she used in painting portraits. She captured what people were really like, their essence, as in her portraits of President John F. Kennedy. She was able to combine her drawing talent with abstract forms and colors such as in the Bacchus (god of wine) paintings. The viewer, if looking carefully, will see the lines of the figure of Bacchus within the patterns and colors. To reach across her huge canvases, often as long as twenty feet, Elaine painted with a brush at the end of a long aluminum pole.

IRENE RICE PEREIRA (U.S., 1907-1971)

Irene Rice Pereira was the first woman to lecture and write books about abstract art. In abstract art, shapes, lines, and colors are beautiful in themselves and do not take on the form of objects.

Irene Rice Pereira, UNTITLED. Mixed media, oil on artist's board, Height: 29½",
Width: 33¼". The Denver Art Museum, Denver Colorado.

Irene's father died when she was fifteen years old. Irene had to earn all the money to take care of her sick mother, two young sisters and brother. She became a secretary during the day and an art student at night. In her early twenties, she experienced the greatest event of her life, a trip to the Sahara Desert. The desert helped her see the vastness of space. Irene tried to show this space in all her future paintings using geometric floating shapes. She sometimes painted on wavy glass which she placed in layers on top of her paintings. Irene gave lectures on abstract art and wrote four books on this subject. One book was translated into Japanese as the people of the Orient liked Irene's ideas about space.

MARISOL (MARISOL ESCOBAR) (France,/Venezuela, 1930-)

Marisol uses humor in her sculpture to make comments about the world. Marisol likes to be called by only one name to be different.

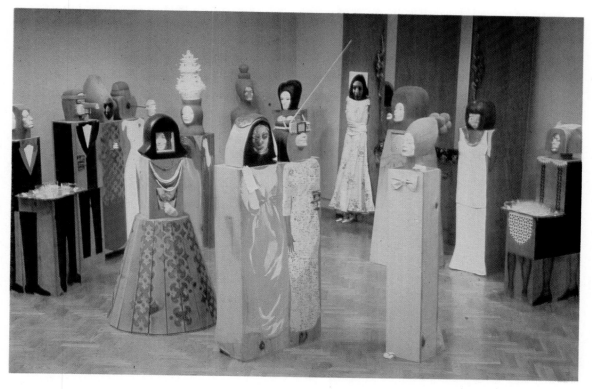

Marisol, THE COCKTAIL PARTY, (1965-66). Painted wood, cloth, plastic, shoes, jewelry, mirror, television set, etc., Fourteen free-standing life-size figures and wall panel. From the collection of Mrs. Robert B. Mayer.

As a child, Marisol often traveled in Venezuela, New York, and her own country of France with her wealthy parents. They encouraged the artistic talent of their shy daughter who did not always follow the "rules." Her art is unique as well as daring. In some of her sculptures, she uses power tools and axes to combine wood with plaster casts and then paints portions of the figures. Her own face and hands have often been the model for the plaster casts. Marisol expresses problems she sees in government, religion and the family through her art. She thinks people will notice what she has to say if her art has gentle or biting humor. In "The Cocktail Party," an art work of fourteen life-size figures, one woman's head is a television set. Marisol may be saying that people no longer think but allow television to act as their brain. People do notice Marisol's work and are challenged to understand what she is saying through art.

CHRYSSA (VARDA CHRYSSA) (Greece,/France,/U.S., 1933-)

Varda Chryssa creates sculpture out of neon lights and outdoor signs.

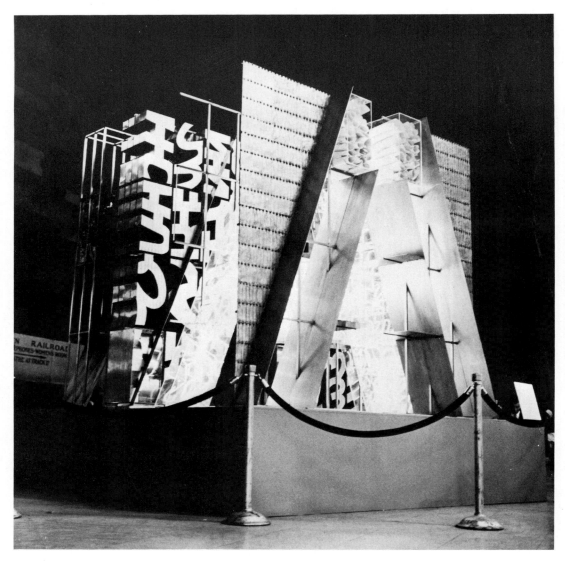

Chryssa, THE GATES TO TIMES SQUARE, (1966). Welded stainless steel, neon and plexiglass, 120″ × 120″ × 120″. Albright-Knox Art Gallery, Buffalo, New York. Gift of Mr. and Mrs. Albert A. List, 1972.

Varda Chryssa was born in Greece, studied art in Paris and moved to the United States when she was twenty-one years old. She studied art in California and then moved to New York City. Known by her last name, Chryssa loved the excitement of New York City, especially the flashing lights of Times Square with the many messages on all the signs. She learned to make outdoor signs and enjoyed using letters of the alphabet in her art work. She experimented with different ideas and began to light up her alphabet letters with colorful neon tubes of light. With the help of glass blowers and metal workers, Chryssa spent two years creating "The Gates of Times Square," a very large art work. The letter A is repeated many times, and might stand for "America," "Advertisement," or "Amazing."

BARBARA HEPWORTH (England, 1903-1975)

Barbara Hepworth created abstract sculptures and is one of England's most important sculptors.

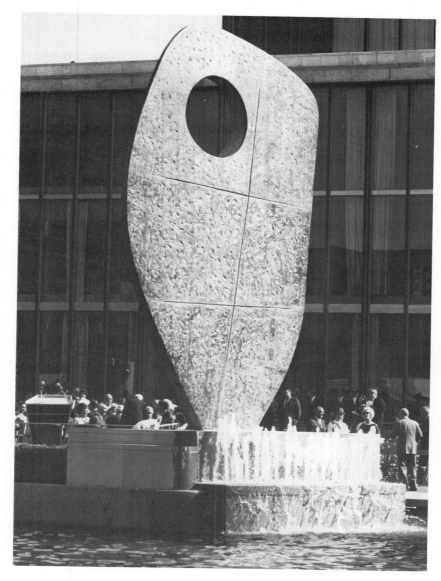

Barbara Hepworth, SINGLE FORM, (1964). Bronze with granite base. Height: 21'. United Nations, New York, through a grant by the Jacob and Hilda Blaustein Foundation, in memory of Dag Hammarskjold. The Barbara Hepworth Museum, Cornwall, England.

When Barbara crossed the English countryside with her father as a young girl, she was aware of the shape of the land, the hollows and the hills. Barbara saw the forms of objects with the eyes of a sculptor. After studying sculpture for several years, she began to carve in wood, stone and marble, which took great physical strength. She enjoyed touching the beautiful natural materials and watching them become what she imagined in her mind. Barbara also created sculptures in bronze. In many of her works, she placed a hole in the center of the sculpture, something other sculptors had never done. Some of the beautiful abstract forms she produced were as high as twenty-one feet, such as the sculpture she created for the United Nations. She married twice, first another sculptor, then a painter and had children with both, including a set of triplets. Barbara enjoyed being a mother and managed to find time daily to sculpt, even if it was at midnight when her children were asleep.

HELEN FRANKENTHALER (U.S., 1928-)

Helen Frankenthaler invented a new way of painting by letting beautiful colors flow and spread on the canvas.

Helen Frankenthaler, SPIRITUALIST, (1973). Acrylic on canvas, 6' × 5'. The Holladay Collection. The National Museum of Women in the Arts.

Helen was lucky because her family, especially her father, encouraged her talent in art by sending her to good schools and giving her art lessons with excellent teachers. Growing up in New York City, she was able to visit many art museums and galleries, meeting artists who were trying new ideas. She married and later divorced the artist Robert Motherwell. Helen invented a new way of painting by not sealing the surface of the canvas with sizing (something like glue) which most artists had done in the past. This caused the paint to soak through the canvas rather than staying on the surface. Her beautiful colors spread across the canvas as they were thinned by turpentine. Her works are abstract, having no recognizable objects in them. Instead her paintings glow with color and give a sense of deep space. Helen Frankenthaler caused many other artists to change the way they painted.

NIKI de SAINT PHALLE (France,/U.S., 1930-)

Niki de Saint Phalle's gaily painted large figures of women are her way of showing the joy of being a female.

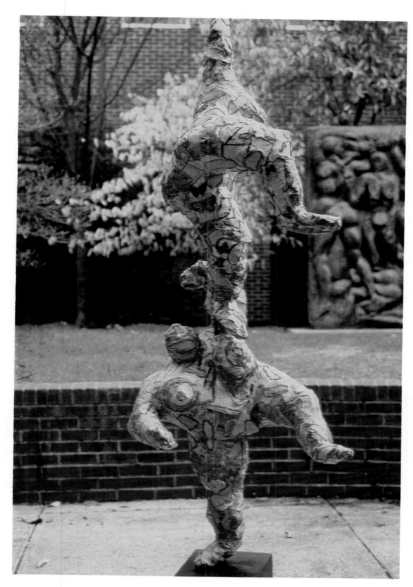

Niki de Saint-Phalle, LOULOU AND MIMI, (1965). Mixed media, Height: 65". From the collection of Mrs. Robert B. Mayer.

Niki was born in France but moved with her family to the United States at age three and became an American citizen. By the age of twenty-two, she was married, the mother of two children, and unhappy in her life. She went back to France to find herself and discovered that work often cures sadness. The work she chose was art. At first she used the art form of shooting a gun at plastic bags which were full of paint and letting the dripping colors create a painting. Many people noticed her unusual artistic methods, including the man who became her second husband. He was an artist who encouraged her. Niki de Saint Phalle was not afraid to try new ideas and began to create large figures of joyful women, brightly painted with flowers and other designs. Niki also is active in theatre, film and print making. Her charming figures can be found in parks, gardens and playgrounds in Europe and the United States.

BEVERLY PEPPER (U.S.,/Italy, 1924-)

Beverly Pepper creates huge abstract welded steel sculptures, sometimes as high as a three story building.

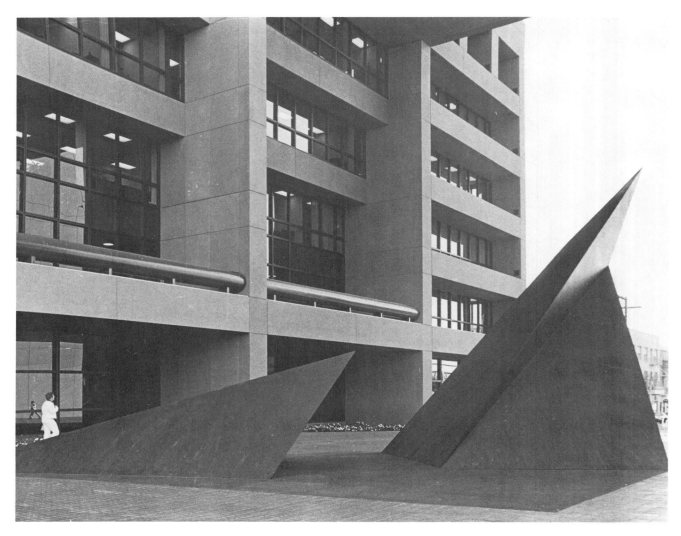

Beverly Pepper, EXCALIBUR, (1975). Steel Painted Black, 32′ × 40′ × 60′ GSA Grant, San Diego, California.

Most students graduate from high school at age eighteen; Beverly Pepper was so smart that she graduated from college at age seventeen. She was raised in New York and after her art school studies became an art director for advertising companies. She was successful in her career, but not happy with it or her marriage. Both ended and with her young son she went to France for further art study. She married again and had one more child. Beverly was a painter but when she was asked to create an outdoor welded sculpture, something she had never done before, she accepted the challenge. Beverly found that she loved designing and building huge outdoor abstract sculptures. Some had brilliant color; some had surfaces as shiny as mirrors. So, at the age of forty, she found a new artistic medium for herself. Beverly now lives in Italy near the workshop where, with the help of cranes, pulleys and very large machines, she creates exciting large sculptures that are shipped all over the world.

MARIA MONTOYA MARTINEZ (U.S., 1881-1980)

Maria Martinez, an American Indian, used clay to form useful and beautiful works of art.

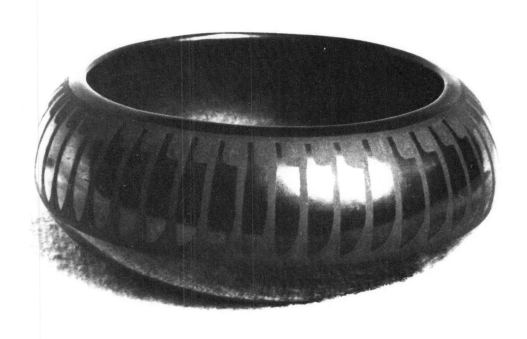

Maria Montoya Martinez, Black-on-black pottery, Height: 3½″, Width: 5¼″. From the collection of Hazel E. Barnes and Doris J. Schwalbe, Boulder, Colorado.

Maria learned to make pottery as a child living in her Tewa Indian village of the San Ildefonso Pueblo of New Mexico. When a man who wanted to find out about ancient Indian pottery found some broken pottery pieces buried deep in the earth, he came to Maria. He asked her to try to put the pieces together and then to make a similar black pot. For 700 years no one had created black pots like this, but Maria and her husband found the secret by smothering the flames while the clay pot was being fired. Maria and her husband then discovered a way to make a black pot shine by polishing the surface with a smooth stone before firing. Maria invented the method of combining the shiny black with a matte (flat) black to make decorations on the pots. She sold so many pots that it became necessary to teach the other women in her villiage her pottery secrets so they too could help. The money they were paid helped all the people in their pueblo. Maria Montoya Martinez's pots are in many museums of the world because they are not only useful, but beautiful works of art.

31

JUDY CHICAGO (U.S., 1939-)

Judy Chicago, a powerful artist, has written books, made films, lectured and created art works that have awakened the world to know the story of all women.

Judy Chicago is a dynamic leader, a trait she learned from her dearly loved father who was a labor leader. When Judy was thirteen, her father died but her mother worked hard so that Judy could get a good education. Judy studied art from elementary school through college. Her first husband died in a car accident, but she did marry again. Judy became aware that most women were not being given an equal chance with men in the art world. She wanted people to know about women's contributions in art and developed the first feminist art class in the U.S., teaching at California State University.

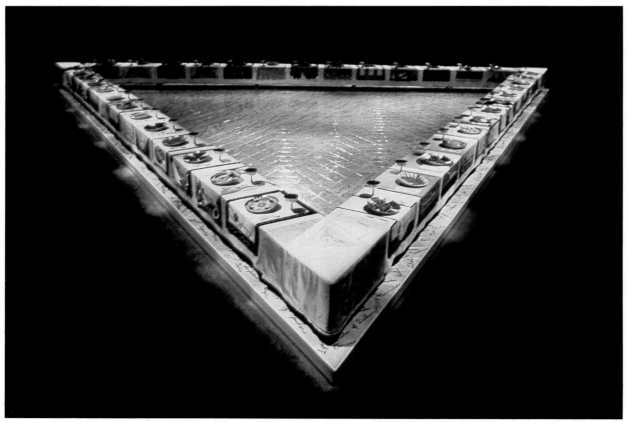

THE DINNER PARTY, © Judy Chicago, (1979). 48 × 48 × 48', multi-media including china-paint on porcelain, ceramic, needlework on fabric. Photographed by Michael Alexander.

Among her many art works, Judy Chicago created the "The Dinner Party," which is so huge that it fills a room almost as large as a basketball court. In addition, Judy has written two books and made one film about this art experience. "The Dinner Party" tells the history of women through thirty-nine place settings, each for a great woman of the past. For five years, Judy guided hundreds of volunteers who created very large china dinner plates and embroidered runners beneath each place setting. They used the needlework style of the time each woman lived. The table rests on 2,300 handcast tiles on which the names of 999 women are written in gold. These women were known for their achievements in many fields such as art, music, science, medicine, and literature. This art work makes people aware of women's talent, power and courage. Women have made wonderful contributions to the world.

Over **21,000** women artists are discussed in Chris Petteys' 1985 book, *DICTIONARY OF WOMEN ARTISTS*, an international dictionary of women artists born before 1900. This page lists only a few of these artists whose names were most often mentioned in various other books read by the author when creating *HISTORY OF WOMEN ARTISTS FOR CHILDREN*.

WOMEN ARTISTS BEFORE THE 16TH CENTURY

Name	Date	Country	Description
Kora	600s B.C.	Greece	First recorded woman artist
Helena	300s B.C.	Greece	Painting
Kalypso	200s B.C.	Greece	Painting
Iaia	c.90 B.C.	Rome	Miniature Portraits
Aristarte	?	Greece	Painting
Timarete	?	Greece	Painting
Olympias	?	Greece	Painting
Ende	c.975	Spain	Illuminated manuscripts
Claricia	1100s	Germany	Illuminated manuscripts
Donella	c.1271	Italy	Illuminated manuscripts
Anastaise	1400s	Italy	Illuminated manuscripts
Caterina dei Vigri	1413-1463	Italy	Painted miniatures, writer
Honorata Rodiana	d.1452	Italy	Fresco painter
Properzia de'Rossi	c.1490-1530	Italy	Marble sculptor

16TH CENTURY

Name	Date	Country	Description
Levina Teerlinc	c.1520-1576	Flanders	Miniature portraits
Catharina Van Hemessen		Flanders	Portrait painter
Diana Ghisi	c.1530-1590	Italy	Sculptor, engraver
Irene Di Spilimberg	c.1540-1560	Italy	Painter
Lucia Anguissola	1540-1565	Italy	Portrait painter
Marietta Tintoretto Robusti	1560-1590	Italy	Portrait painter
Fede Galizia	1578-1630	Italy	Still-lifes, portraits
Clara Peeters	c.1589-1659	Belgium	Still-life painter

17TH CENTURY

Name	Date	Country	Description	Name	Date	Country	Description
iovanna Garzoni	1600-1670	Italy	Studies of plants & animals, portraits	Elizabeth Cheron	1648-1711	France	Historical paintings, portraits
nna Maria Van Schurman	1607-1678	France	Oil & pastel painter, wood & ivory carver	Margaretha de Heer	1650s	Holland	Bird and insect painter
ouise Moillon	1610-1696	France	Still-life fruit painter	Joanna Koerten	1650-1715	Holland	Drawings, paintings, embroidery
ucrina Fetti	1614-1651	Italy	Religious paintings, portraits	Luisa Roldan	1656-1704	Spain	Carved wood Church sculptures
aria van Oosterwyck	1630-1693	Holland	Flower painter	Maria de Abarca	c.-1656	Spain	Portrait painter
atherine Duchemin	1630-1698	France	Flower painter, first woman in French Academy	Margherita Caffi	1662-1700	Italy	Flower painter
ary Beale	c.1632-1699	England	Portrait painter	Henrietta Johnston	1670-1728	U.S.A.	Pastel portraits
isabetta Sirani	1638-1665	Italy	Portraits, Biblical themes	Anna Wasser	1676-1713	Swiss	Portraits, flowers, miniatures
enevieve de Boulogne	1645-1708	France	Landscapes, fruit, flower painter	Marie Catherine Silvestre	1680-1743	France	Pastel portraits
adeleine de Boulogne	c.1646-1710	France	Decorated palaces	Giulia Lama	c.1685-1753	Italy	Portraits, religious paintings

18TH CENTURY

Name	Date	Country	Description	Name	Date	Country	Description
a Dorothea Lisiewska-Therbusch	1721-1782	Germany	Portraits, scenes of daily life	Barbara Krafft	1764-1825	Czech/Ger	Portraits, historical subjects
herine Read	1723-1778	Scotland	Pastel portraits	Constance Marie Charpentier	1767-1841	France	Portraits, scenes of daily life
resa Concordia Mengs	1725-1808	Bohemia	Pastel portraits, miniatures	Marie Guillemine Benoist	1768-1826	France	Portraits, historical subjects
coise Duparc	1726-1778	France	Scenes of daily life, portraits	Ellen Sharples	1769-1849	England	Portraits, miniatures
e Suzanne Giroust-Roslin	1734-1772	France	Pastel portraits	Angélique Mongez	1775-1855	France	Myth & historical paintings, portraits
y Moser	1744-1819	England	Flower painter	Pauline Desmarquets Auzou	1775-1835	France	Historical paintings, portraits
e Vallayer-Coster	1744-1818	France	Still-life painter	Antoinette Haudebourt-Lescot	1784-1845	France	Portraits, scenes of daily life
e-Anne Collot	1748-1821	France	Sculptor in marble & bronze	Sarah Goodridge	1788-1853	U.S.A.	Miniature portraits on ivory
aide Labille-Guiard	1749-1803	France	Pastel and oil portraits	Marie Ellenrieder	1791-1863	Germany	Religious paintings, portraits
e Victoire Lemoine	1754-1820	France	Portraits, scenes of daily life	Anna Claypoole Peale	1791-1878	U.S.A.	Still-lifes, miniatues, portraits
anna Candida Dionigi	1756-1826	Italy	Landscape painter, author	Rolinda Sharples	1794-1838	England	Portraits, history paintings
e Gabrielle Capet	1761-1817	France	Pastel portraits, miniatures	Margaretta Angelica Peale	1795-1882	U.S.A.	Still-lifes
guerite Gérard	1761-1837	France	Life scenes, portraits, miniatures				

19TH CENTURY

Name	Date	Country	Description	Name	Date	Country	Description
Stuart	1812-1888	U.S.A.	Portraits, Bible scenes	Marianne Von Werefkin	1860-1938	Russia	Expressionist painter
a Stebbins	1815-1882	U.S.A.	Sculpted in marble & bronze	Florine Stettheimer	1871-1944	U.S.A.	Still-lifes, portraits
Whitney	1821-1915	U.S.A.	Sculpted in marble & bronze	Romaine Brooks	1874-1970	U.S.A.	Portrait painter
Martin Spencer	1822-1902	U.S.A.	Portraits, scenes of daily life	Paula Modersohn-Becker	1876-1907	Germany	Peasant women, still-lifes
a Lander	1826-1923	U.S.A.	Marble sculptor	Gwen John	1876-1939	Wales	Portraits of women
Newton	1832-1866	England	Portraits, landscapes	Anna Hyatt Huntington	1876-1973	U.S.A.	Life-size animal bronze park sculptures
eth Ney	1833-1907	U.S.A.	Sculpted in marble & bronze	Gabriele Munter	1877-1962	Germany	Landscapes, portraits
e Morisot	1841-1895	France	Impressionist painter	Meta Warrick Fuller	1877-1968	U.S.A.	Sculptor of black social issues
Bracquemond	1841-1916	France	Impressionist painter	Laura Wheeler Waring	1887-1948	U.S.A.	Painter Afro-American subjects
e Ream Hoxie	1847-1914	U.S.A.	Sculpted marble Abe Lincoln	Vanessa Bell	1879-1961	England	Portraits, still-lifes
Cabot Perry	1848?-1933	U.S.A.	Landscapes, poet, lecturer	Natalya Goncharova	1881-1962	Russia	Painter, costume design, illustrator
onzales	1849-1883	France	Impressionist painter	Alexandra Exter	1882-1949	Russia	Painting, costume design
Elizabeth Butler	1850-1933	England	Painter of military subjects	Clementine Hunter	1882?-1988	U.S.A.	Black life in rural south painter
se Schwartze	1851-1918	Holland	Portraits, still-lifes	Marie Laurencin	1885-1956	France	Painter, print maker, poet
a Beaux	1855?-1942	U.S.A.	Portraits	Sonia Terk-Delaunay	1885-1979	Rus/Fr	Abstract painter, illustrator, costume design
Elizabeth Klumpke	1856-1942	U.S.A.	Portraits, landscapes, Bonheur biographer	Olga Rozanova	1886-1918	Russia	Painting industrial art
Bilinska	1858-1893	Poland	Portraits, landscapes	Malvina Hoffman	1887-1966	U.S.A.	Sculptor in bronze
e Abbema	1858-1927	France	Portraits, sculpture	Marguerite Zorach	1887-1968	U.S.A.	Fauvist and cubist painter
Barber Stephens	1858-1932	U.S.A.	Portraits, landscapes	Liubov Popova	1889-1924	Russia	Abstract still-lifes, portraits
Bashkirtseff	1859-1884	Russia	Portraits, author	Alma Thomas	1891-1978	U.S.A.	Abstract art, vibrant color mosaics
Mary (Grandma) Moses	1860-1961	U.S.A.	Rural scenes, landscapes	Kay Sage	1898-1963	U.S.A.	Surrealist painting
ne Valadon	1865-1938	France	Portraits, still-lifes, landscapes	Anni Albers	1899-1994	U.S.A.	Textile art

Additional books by Vivian Sheldon Epstein
available by ordering from
your local bookstore, wholesale distributor or
VSE Publisher, 212 South Dexter Street, Denver, Colorado 80246

A Common thread among all these books is the elimination of prejudice and the growth of the individual through knowledge that the world is open to us with many possibilities. Role models of the past are depicted to inspire young people. The author believes that changes in societal attitudes can best be created by instilling positive ideas within young people.

HISTORY OF WOMEN IN SCIENCE FOR YOUNG PEOPLE

A topic never before approached for ages 9-l4. Exciting and challenging lives of women scientists encourages girls to become involved in science. Approved and applauded by educators, librarians, and scientists in many fields. The American Association for the Advancement of Science called it one of the best science books for young people since l992. National Science Teachers Association..."charming portraits...written carefully...excellent resource" (September l994.) 40 pages 8"x12", 13 in full vibrant color.
Soft Cover: $ 7.95 retail ISBN 0-960l002-7-X
Hard Cover: $l4.95 retail ISBN 0-9601002-8-8

HISTORY OF COLORADO'S WOMEN FOR YOUNG PEOPLE

..."unique glimpse into the lives and contributions of women who have had a profound impact on life in Colorado...a gold mine of useful and inspirational information....superb writing and illustrations.."Sherman G. Finesilver, Retired Chief Judge, United States District Court for the District of Colorado; ..."well-researched work about the important roles that women played in the history of Colorado. What a refreshing resource for our young people!" Elizabeth Stansberry, Social Studies Coordinator, Denver Public Schools; ..."Vivian Sheldon Epstein has provided a well-researched chronology of the past which has the potential to influence the future." Nola Wellman, Ph.D., Executive Director of Middle Schools, Cherry Creek School District, Englewood, Colorado. 56 pages, 8"x12", l6 in full vibrant color.
Soft Cover: $ 9.95 retail ISBN 1-891424-00-9
Hard Cover: $l6.95 retail ISBN 1-891424-01-7

HISTORY OF WOMEN FOR CHILDREN

The Council on Interracial Books for Children called this book **"EXTRAORDINARY."** For the first time, a chronological story of the history of women for children is told; ages 5 to 12. Highlighted as one of five of the best 600 children's books by *A Guide to Non-Sexist Children's Books, Vol. II: 1976-1985.* 32 pages, 8"x12", 8 in full vibrant color.
Soft Cover: $ 6.95 retail ISBN 0-960l002-3-7
Hard Cover: $l3.95 retail ISBN 0-960l002-4-5

THE ABCS OF WHAT A GIRL CAN BE

Delightful alphabet book describing wide range of professions available to women today, all with non-sexist job titles. Attractive color drawings accompany rhyming text. 32 pages, 8"x12", 8 in full vibrant color.
Soft cover $6.95 retail ISBN 0-960l002-2-9

In sharing these books with younger readers, you are helping to create positive change.

Please add $1.50 postage and sales tax.